Eran Shakine

Eran Shakine

A Muslim, a Christian and a Jew Knocking on Heaven's Door

Edited by Jürgen B. Tesch
With a preface by Edward van Voolen

Edition Jürgen B. Tesch

HIRMER

Vielleicht fällt es Ihnen in diesen Tagen nicht so stark auf, aber Muslime, Christen und Juden haben vieles gemeinsam. Einen einzigen Gott? Ja, wenn Sie sich nicht an der Dreifaltigkeit stoßen. Und wenn Ihnen die vielen Namen nichts ausmachen, mit denen er bezeichnet und angerufen wird: Gott, Vater, Allah und viele andere. Die drei Religionen teilen dieselbe Bibel? Auf gewisse Weise schon: den Christen galt die jüdische Bibel als alt, so dass sie ihr eine Ergänzung hinzufügten. Die Muslime wiederum stützen sich auf einen völlig unterschiedlichen Text, der dieselben Geschichten auf andere Art erzählt. Die Christen lesen das Alte Testament durch die Brille des Neuen Testaments und mit den Augen Jesu, der diejenigen Teile ignoriert, die er nicht mag. Die Juden sind not amused. Hunderte Jahre später löste der Prophet Mohammed das Problem, indem er verkündete: Ihr habt beide Unrecht; Ihr habt die Geschichten völlig missverstanden. Lest meinen Text!

Der Moslem, der Christ und der Jude stehen auf dem Boden einer gemeinsamen Geschichte. Sie sind miteinander verwandt: ein Sohn Abrahams, Ismael, ist der Ahnherr der Muslime, und der andere, Isaak, der Vorfahre der Juden. Und Jesus wurde als Jude geboren. Sie gehören also zu einer Familie, und das erklärt, warum sie sich ähnlich sehen. Typisch für sie ist, dass sie es lieben, zu diskutieren, zu streiten und sich wieder zu versöhnen. Jeder erzählt seine oder ihre Geschichte auf seine oder ihre eigene Weise. Aber sie alle stimmen in einer Sache überein: wenn sie an der Himmelspforte anklopfen und Einlass begehren, tun sie das nicht nur mit einem gewissen Sinn für Humor, sondern auch, um der Liebe Gottes teilhaftig zu werden.

Eran Shakine hat die Gabe, uns seine Träume von unterschiedlichen Verhaltensweisen in unserem Alltagsleben in seiner einzigartigen Bildsprache zu zeigen.

Edward van Voolen

Preface

Perhaps you don't notice it so much these days, but
Muslims, Christians and Jews have quite a lot in common.

One God? Yes, if you don't stumble over the Trinity. And
if you don't care what you call him: G'd, Father, Allah or
a number of other names. They share the same Bible?
In a way: Christians consider the Jewish Bible old and
added a new supplement. Muslims have a different text
altogether, and tell the same stories in a different way.
Christians read the Old Testament through the eyes of the
New Testament and Jesus, who ignores the parts he does
not like. Jews are not amused. Hundreds of years later, the
Prophet Mohammed solved the problem, saying: you both
got it wrong; you misunderstood the stories completely.
Read my text!

The Muslim, the Christian and the Jew share a common
history. They are related: one son of Abraham, Ismail, is the
ancestor of the Muslims; and the other, Isaac, the ancestor
of the Jews. And Jesus was born Jewish. So they belong
to one family, and that explains why they look alike.
Typically, they love to argue, to quarrel and to become
reconciled again. Each one tells his or her story in his
or her own way. But they all agree on one thing: when they
are knocking on Heaven's Door, they do so not only with
a sense of humor but also to find the love of God.

In his unique pictorial language Eran Shakine is able to
show us his dreams of a different behavior in our daily life.

Edward van Voolen

A Muslim, a Christian and a Jew
Looking for The Love Of God
2014
Oil paintstick on canvas
120 × 100 cm

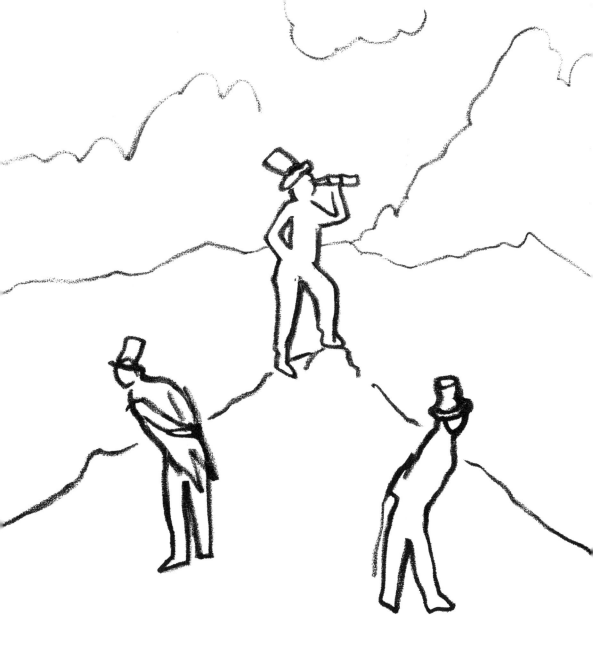

MUSLIM
A CHRISTIAN AND A JEW LOOKING FOR THE LOVE OF GOD

A Muslim, a Christian, and a Jew
and the Finger of God
2012
Oil paintstick on canvas
120 × 100 cm

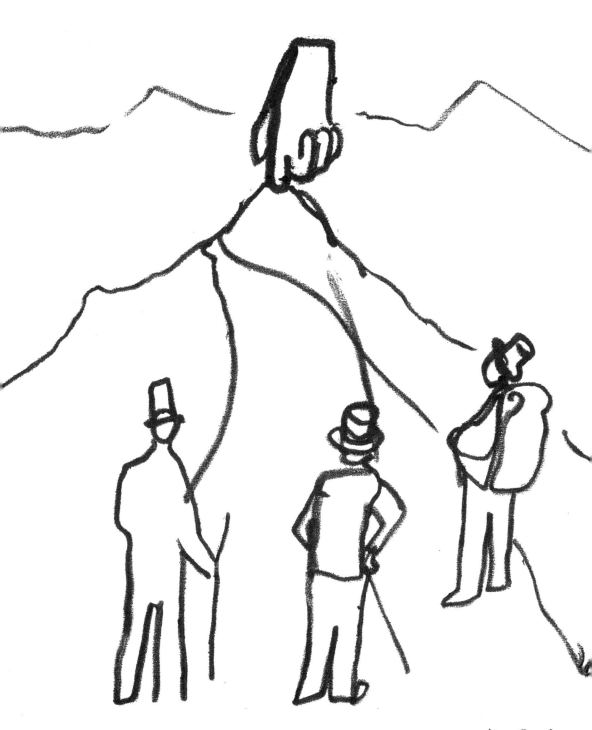

MUSLIM A CHRISTIAN & A JEW. AND THE FINGER OF GOD

A Muslim, a Christian and a Jew
Trying to Think What To Do Next
2016
Oil paintstick on canvas
140 × 80 cm

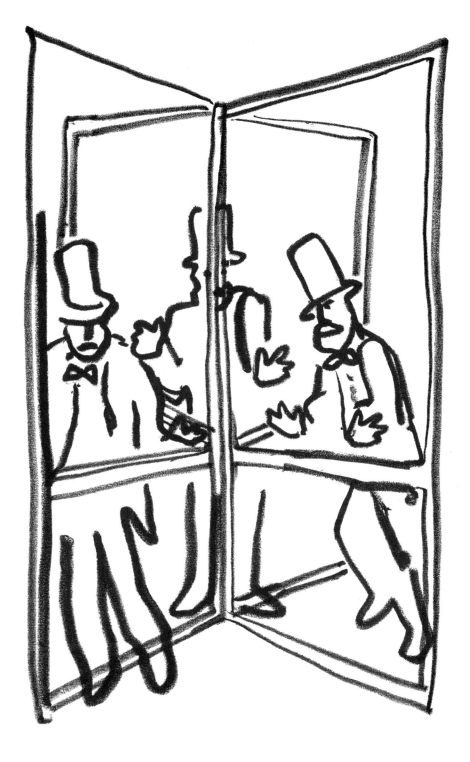

A MUSLIM
A CHRISTIAN & A JEW TRYING TO THINK
WHAT TO DO NEXT

A Muslim, a Christian and a Jew
Visiting Moses, San Pietro in Vincoli
2014
Oil paintstick on canvas
120 × 90 cm

A Muslim, a Christian and a Jew
Meeting Buddha
2016
Oil paintstick on canvas
100 × 140 cm
▷▷

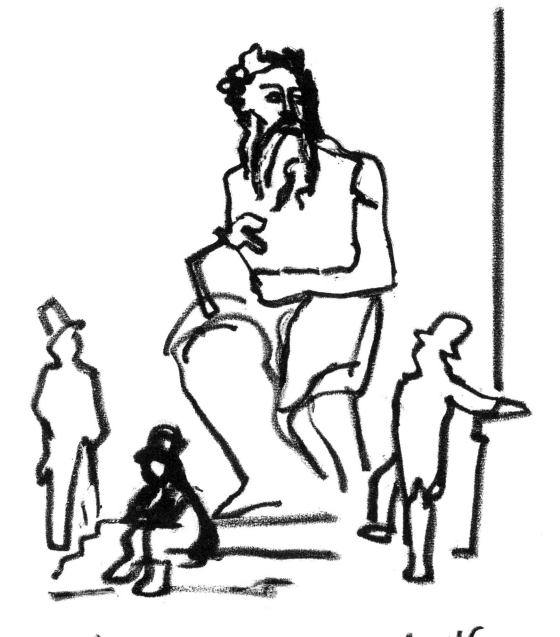

A MUSLIM CHRISTIAN & A JEW VISITING MOSES
SAN-PIETRO IN VINCOLI

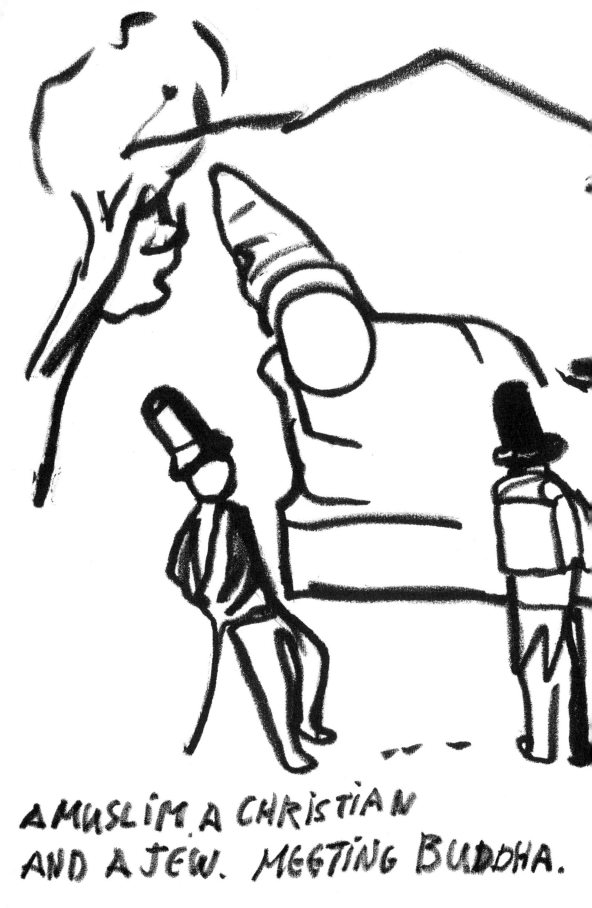

A MUSLIM. A CHRISTIAN AND A JEW. MEETING BUDDHA.

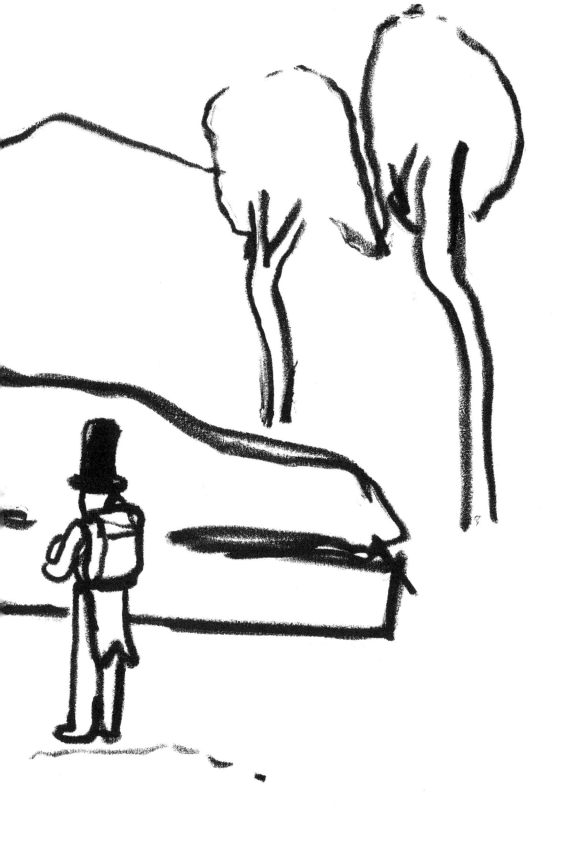

A Muslim, a Christian and a Jew
Deciding to Live on Critical Thinking and Hope
2015
Ink on paper
29.7 × 21 cm

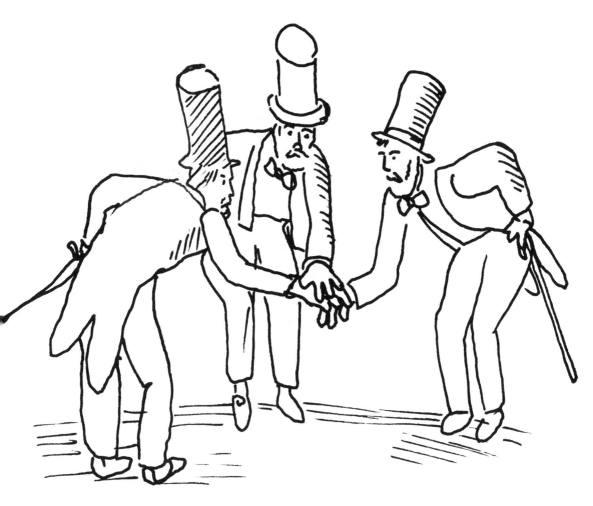

M.C. AND A J.

DECIDING TO LIVE ON
CRITICAL THINKING AND
HOPE

A Muslim, a Christian and a Jew
Crossing the Jordan River
2012
Oil paintstick and acrylic on canvas
110 × 100 cm

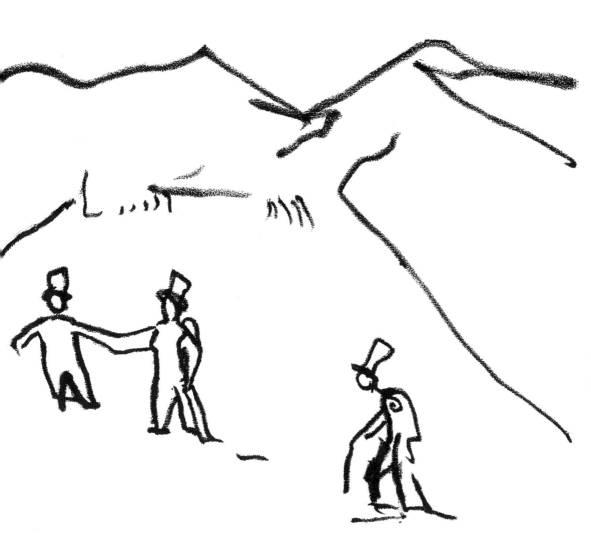

MUSLIM.
A CHRISTIAN AND A JEW CROSSING THE RIVER
JORDAN

A Muslim, a Christian and a Jew
Know You Have to Practice, Practice, Practice
2015
Ink on paper
21 × 29.7 cm

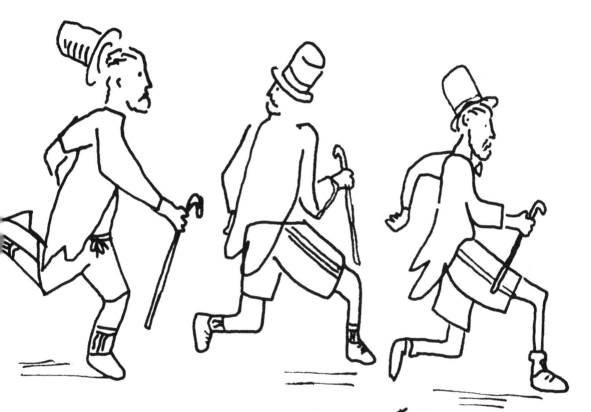

A MUSLIM . A CHRISTIAN AND A JEW
KNOW YOU HAVE TO:
PRACTICE , PRACTICE , PRACTICE.

A Muslim, a Christian and a Jew
Look at the Possibility This is All just a Dream
Which One of Them will Awake from and the
Others will Vanish Back into his Subconscious
2016
Oil paintstick on canvas
100 × 80 cm

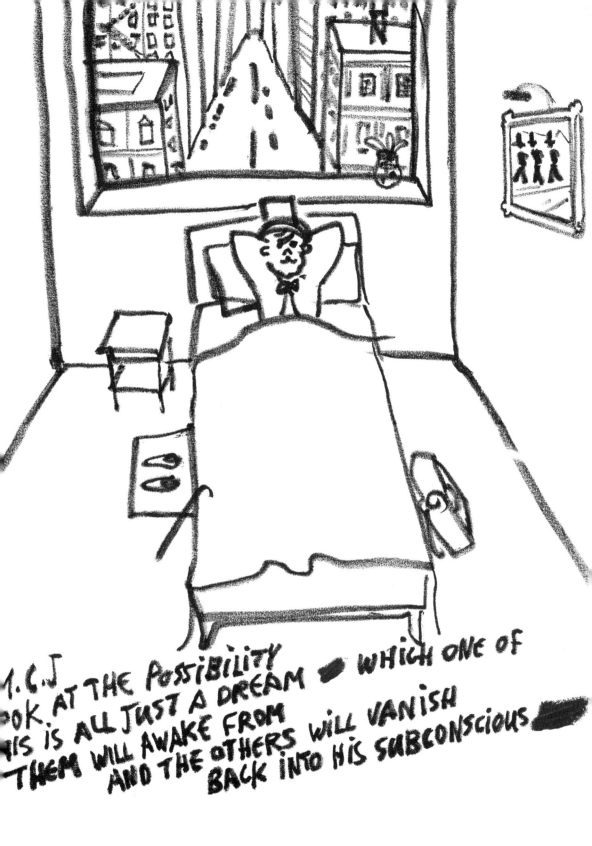

A Muslim, a Christian and a Jew
Looking at the Future of Contemporary Art
2016
Oil paintstick on canvas
100 × 80 cm

M.C.J.
LOOKING AT THE FUTURE OF
CONTEMPORARY ART.

A Muslim, a Christian and a Jew
Looking for a Different Method of Communication
2016
Oil paintstick on canvas
120 × 80 cm

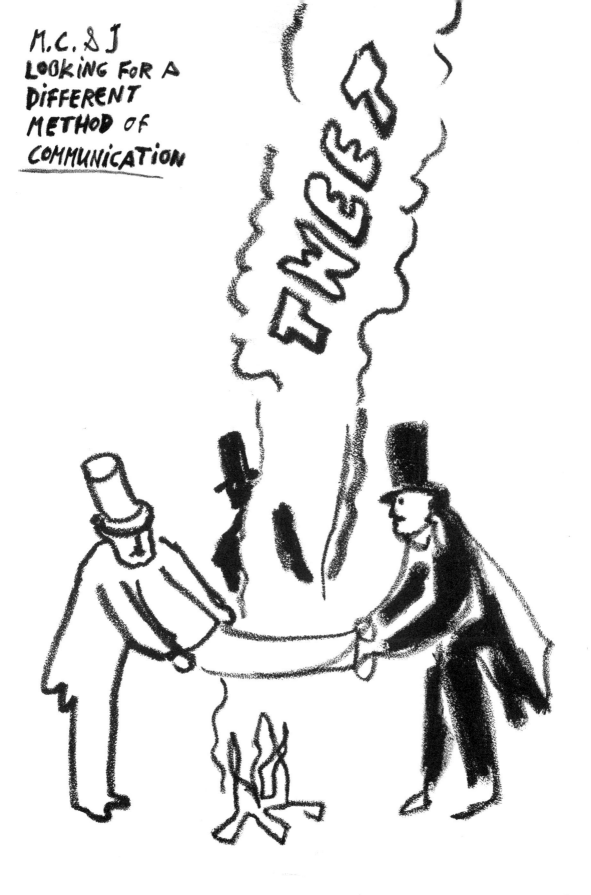

A Muslim, a Christian and a Jew
Knocking on Heaven's Door
2016
Oil paintstick on canvas
140 × 90 cm

A MUSLIM
A CHRISTIAN
AND A JEW
KNOCKING ON
HEAVEN'S DOOR

A Muslim, a Christian and a Jew
Suddenly See Things Differently
2016
Oil paintstick and acrylic on canvas
120 × 100 cm

A Muslim, a Christian and a Jew
Find a Way to Cheat Time at the Time Tunnel
2015
Oil paintstick, acrylic and pencil on paper
29.7 × 42 cm
▷▷

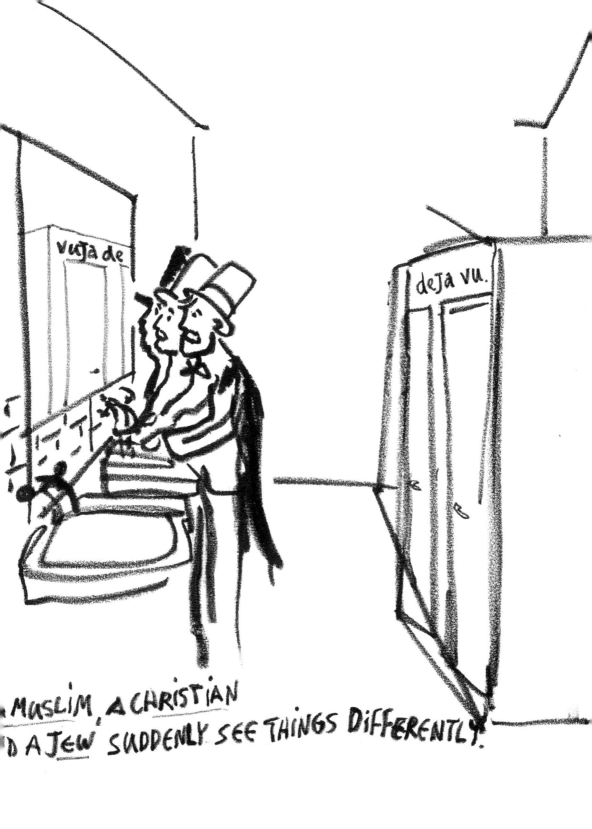

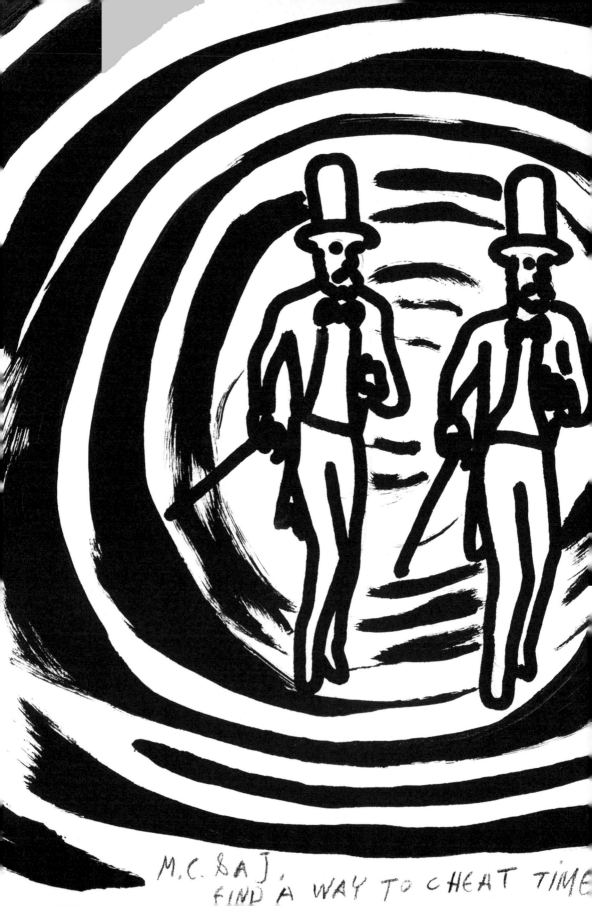

M.C. & J.
FIND A WAY TO CHEAT TIME

THE TIME TUNNEL

A Muslim, a Christian and a Jew
Trying to Figure Out God's Plan
2015
Oil paintstick and acrylic on canvas
150 × 100 cm

A MUSLIM. A CHRISTIAN AND
A JEW
TRYING TO FIGURE OUT
GOD'S PLAN

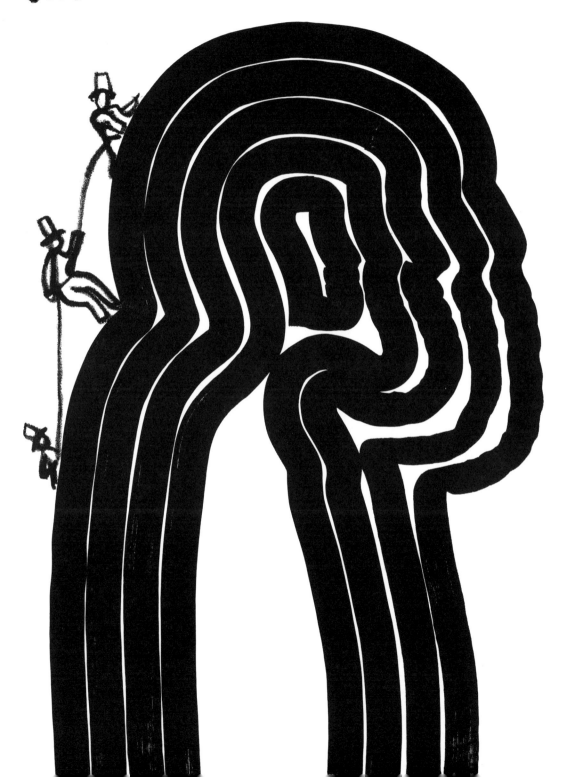

A Muslim, a Christian and a Jew
Realized that the Truth is in the Eye
of the Beholder
2016
Oil paintstick and acrylic on canvas
90 × 80 cm

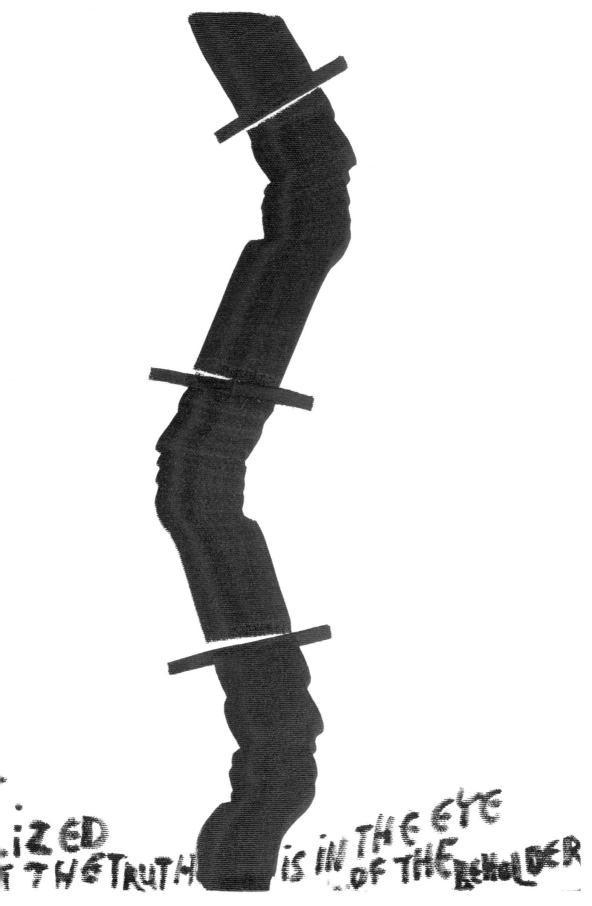

iZED
T THE TRUTH IS IN THE EYE
OF THE BEHOLDER

A Muslim, a Christian and a Jew
Learning to Trust Again
2016
Oil paintstick on canvas
100 × 80 cm

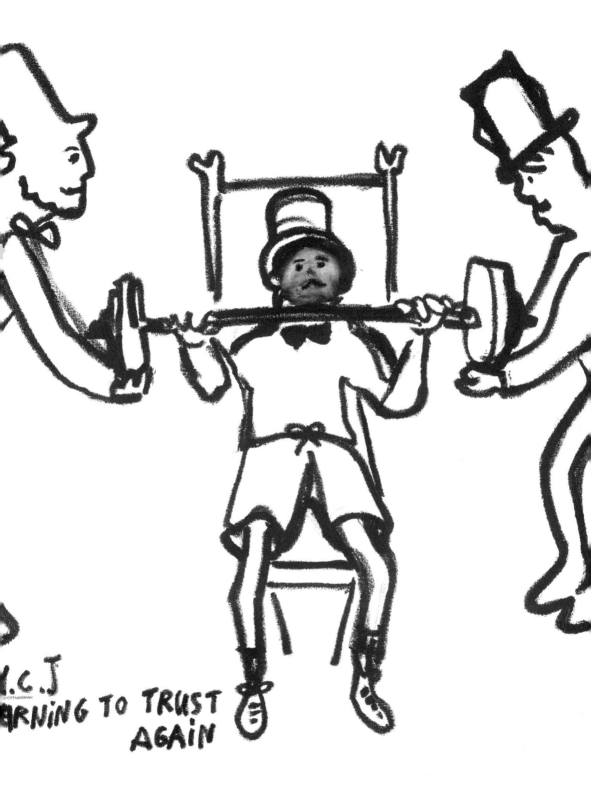

Y.C.J
RNING TO TRUST
AGAIN

A Muslim, a Christian and a Jew
Master the Art of Tactics and
Teamwork at the Tour de France
2016
Oil paintstick on paper
42 × 29.7 cm

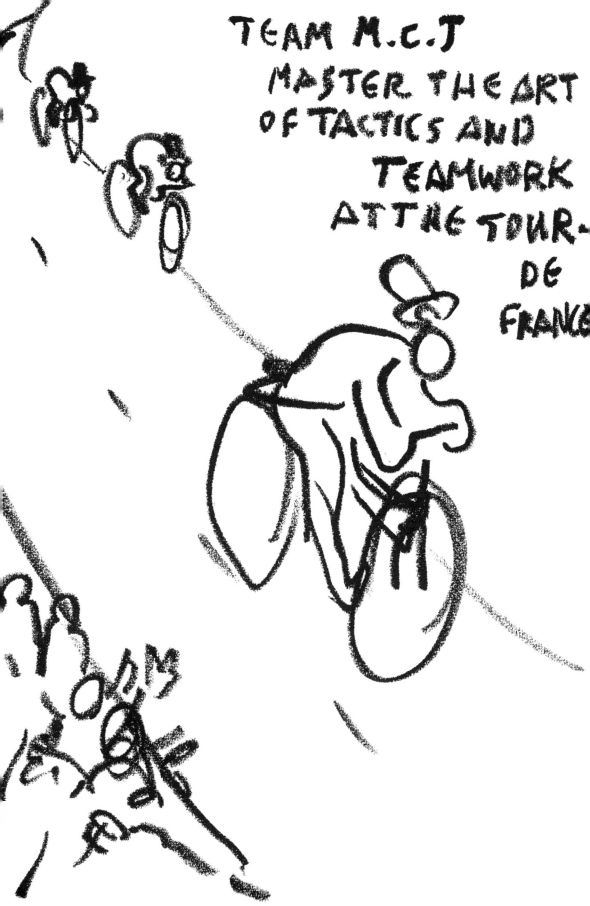

TEAM M.C.T
MASTER THE ART
OF TACTICS AND
TEAMWORK
AT THE TOUR-
DE
FRANCE

A Muslim, a Christian and a Jew
If There is no Foundation of Knowledge, Do We Think We
Know Truths Because Others Repeat them Back to Us?
2016
Oil paintstick on canvas
80 × 130 cm

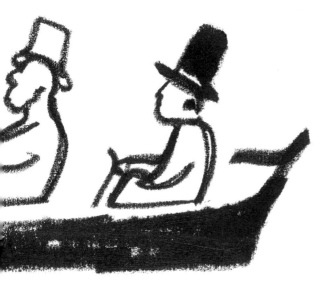

F KNOWLEDGE, DO

S BECAUSE OTHERS REPEAT THEM BACK TO US?

A Muslim, a Christian and a Jew
See the Truth
2016
Oil paintstick on canvas
140 × 90 cm

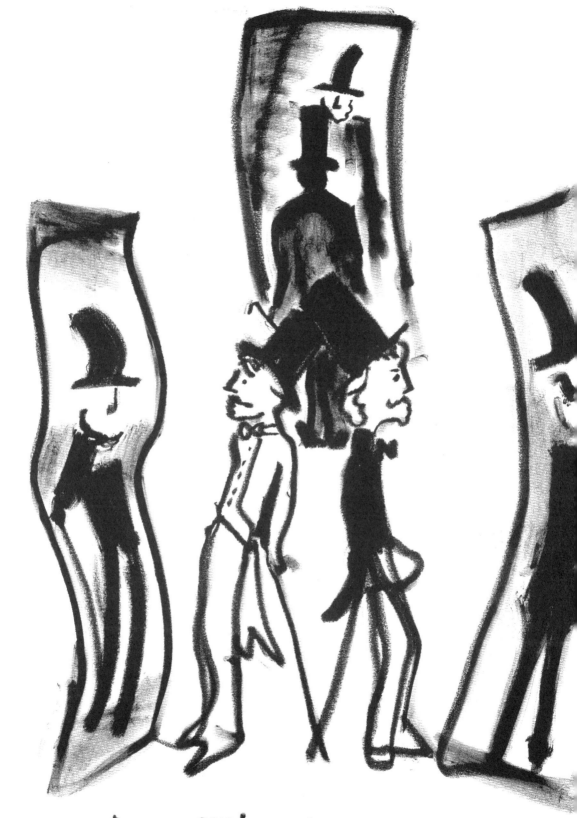

A MUSLIM A CHRISTIAN
AND. A JEW. SEE THE TRUTH

Muslim, a Christian and a Jew
Think They are Ready for a Life Long Commitment
2016
Oil paintstick on canvas
90 × 120 cm

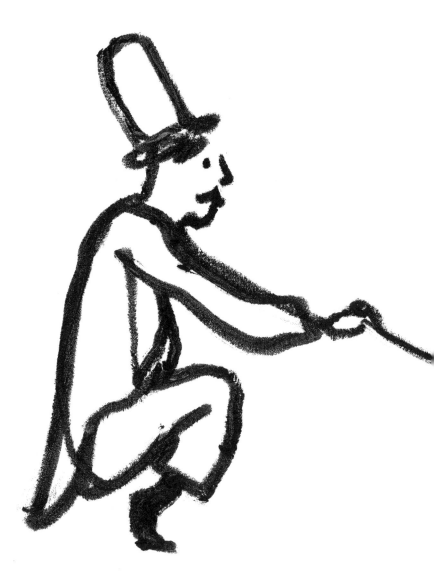

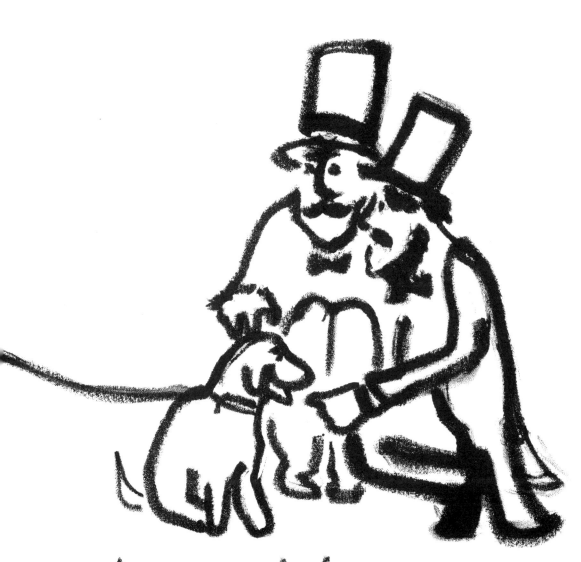

MUSLIM, A CHRISTIAN AND A JEW. THINK THEY ARE READY FOR A LIFE LONG COMMITMENT

A Muslim, a Christian and a Jew
On the Road Once Again
2016
Oil paintstick on canvas
40 × 80 cm

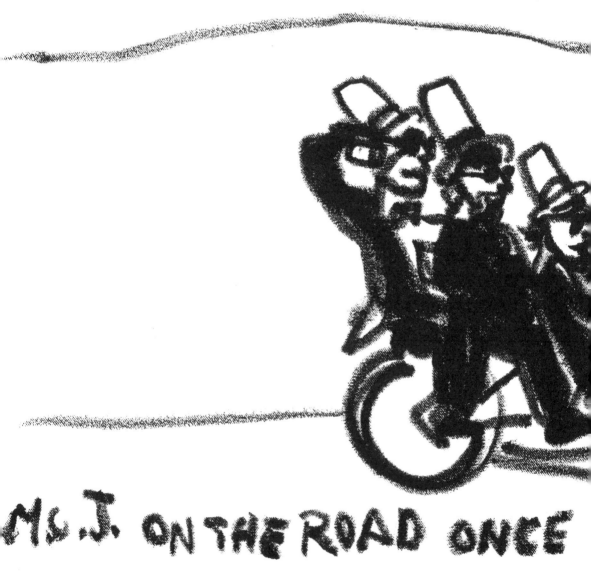

A Muslim, a Christian and a Jew
Learning to Play in Tune
2016
Oil paintstick on canvas
60 × 90 cm

M.C.
LEARN
PLAY

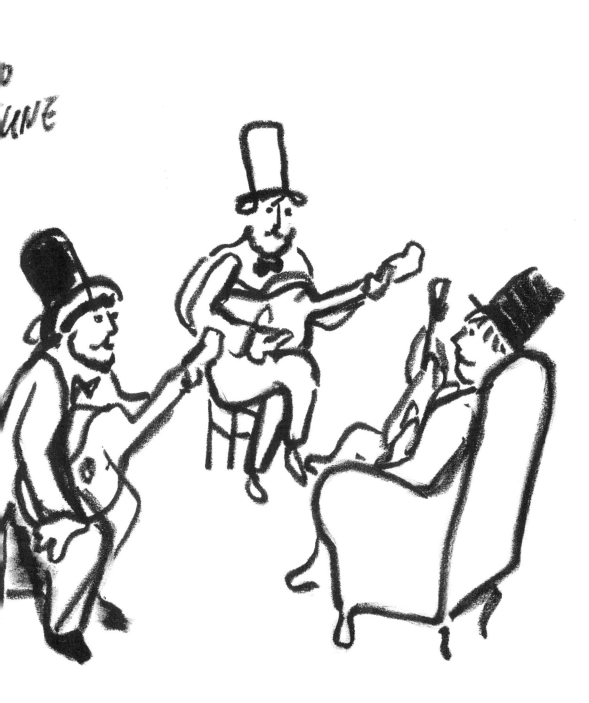

A Muslim, a Christian and a Jew
Realizing it is Preferable to Use Other
People's Experience to Predict the Future
2016
Oil paintstick on canvas
90 × 80 cm

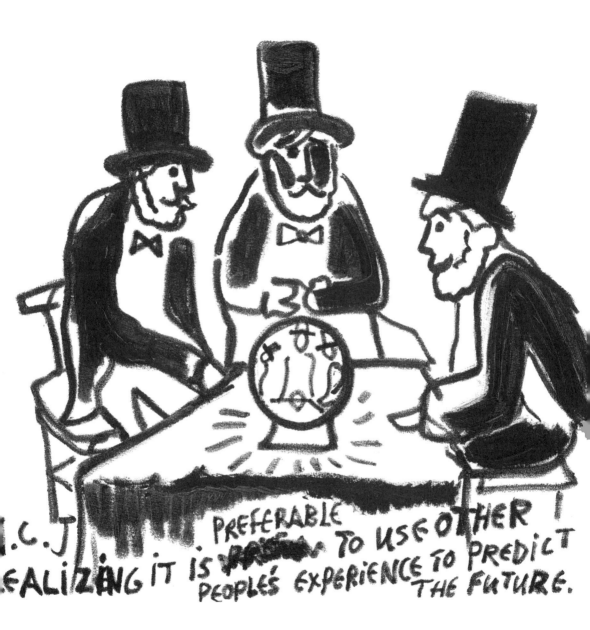

I.C.J
~~REALIZING~~ IT IS PREFERABLE ~~PRICE~~ TO USE OTHER PEOPLE'S EXPERIENCE TO PREDICT THE FUTURE.

A Muslim, a Christian and a Jew
Visiting the Monument
2014
Oil paintstick on canvas
110 × 100 cm

A MUSLI
A

CHRISTIAN
A JEW VISITING THE MONUMENT,

A Muslim, a Christian and a Jew
Answering All the Hard Questions
2016
Oil paintstick on canvas
100 × 140 cm

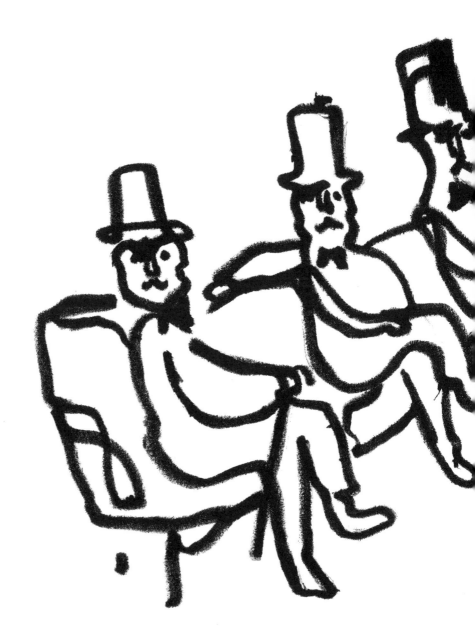

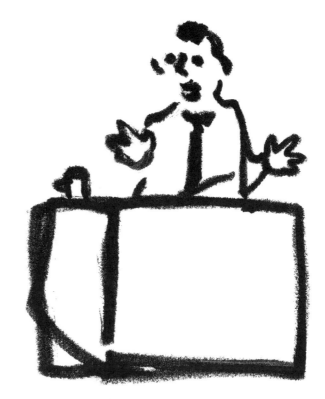

M A CHRISTIAN AND A JEW
RING ALL THE HARD
QUESTIONS.

A Muslim, a Christian and a Jew
Visiting Some Friends
2016
Oil paintstick on paper
56 × 78 cm

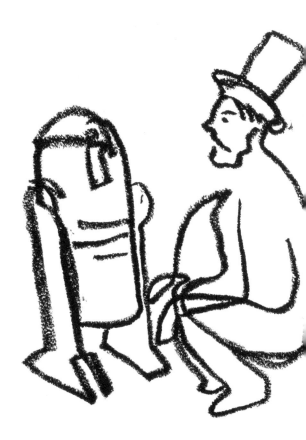

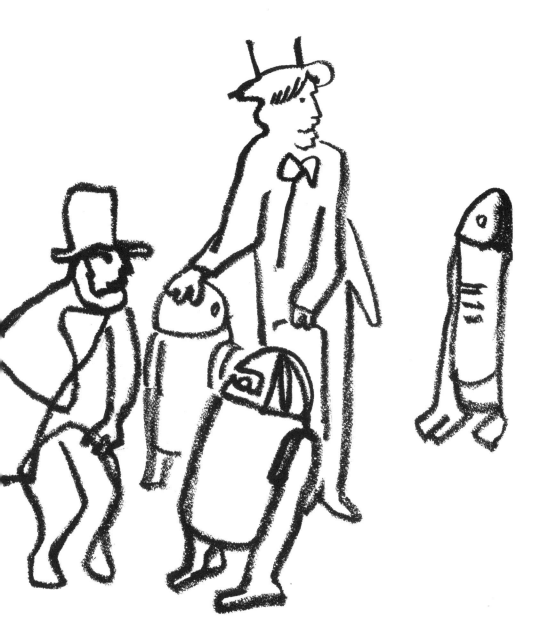

M.C.J
ISITING SOME FRIENDS

A Muslim, a Christian and a Jew
Choosing Their Weapons
2016
Ink on paper
29.7 × 21 cm

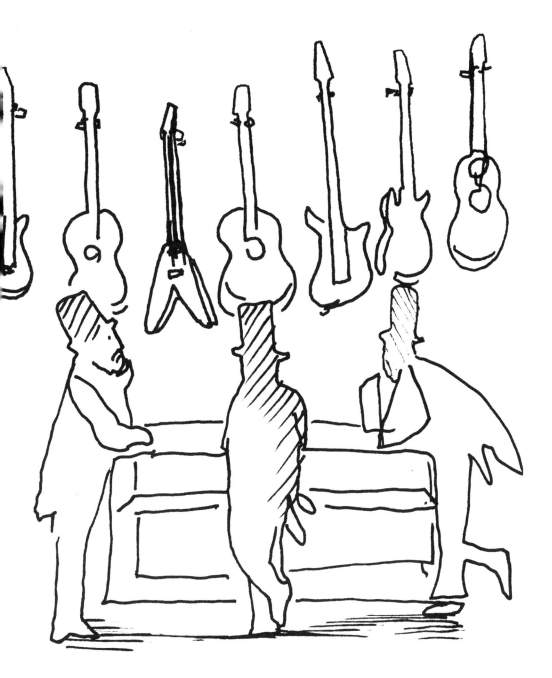

A MUSLIM, A CHRISTIAN
AND
A JEW
THEIR WEAPONS
CHOOSING

A Muslim, a Christian and a Jew
Listening to the Sounds of Nature
2015
Ink on paper
29.7 × 21 cm

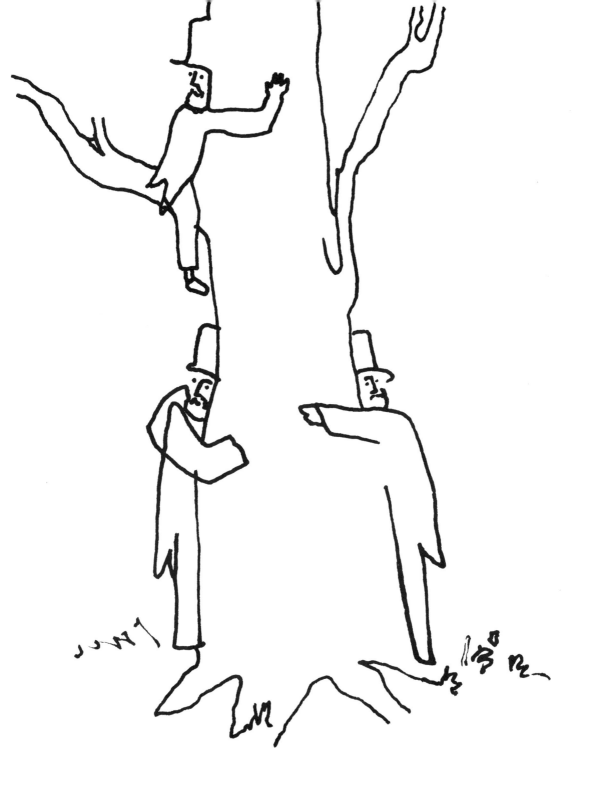

M.C.&J

LISTENING TO THE SOUNDS OF NATURE

A Muslim, a Christian and a Jew
Comparing the Stories They Tell Themselves
2015
Ink on paper
29.7 × 21 cm

M.C. AND A J.
COMPARING THE STORIES
THEY TELL THEMSELVES

A Muslim, a Christian and a Jew
Learn the Benefit of Coordinating
2016
Oil paintstick and acrylic on canvas
130 × 80 cm

A Muslim, a Christian and a Jew
Fundraising in the Town Square
2016
Oil paintstick and acrylic on canvas
90 × 130 cm
▷▷

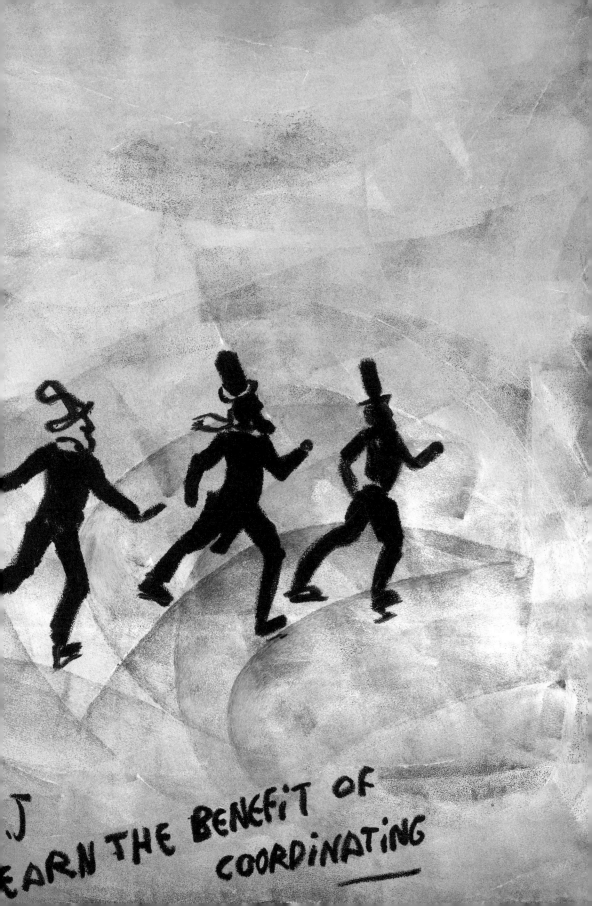

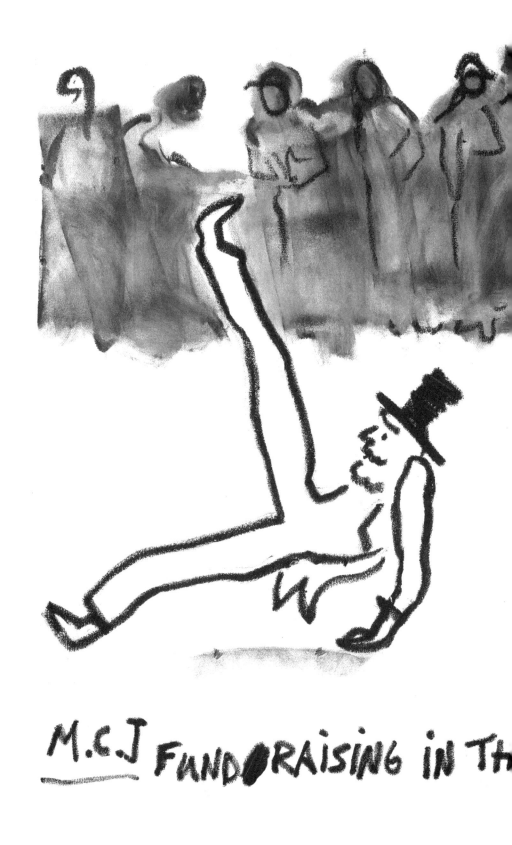

M.C.J FUNDRAISING IN TH

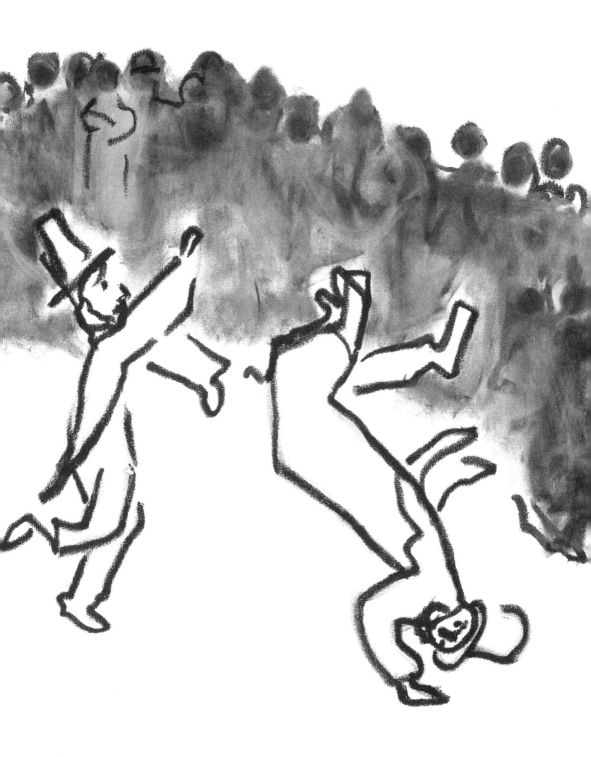

OWN SQUARE.

A Muslim, a Christian and a Jew
Announcing the Official Hugging a Tree Day!
2015
Oil paintstick on paper,
42 × 29.7 cm

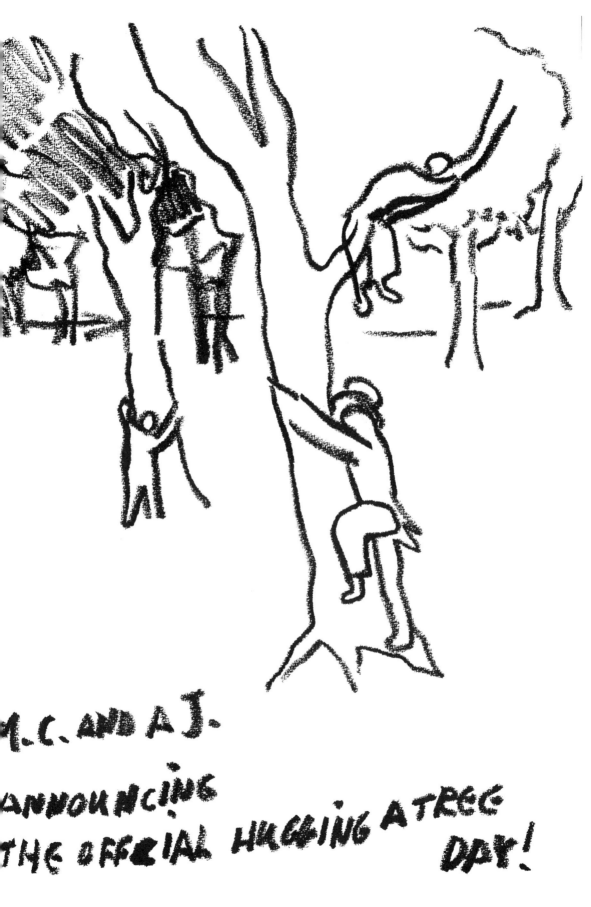

M.C. AND A.J.

ANNOUNCING
THE OFFICIAL HUGGING A TREE
DAY!

A Muslim, A Christian And A Jew
Saving the Last Bees
2016
Oil paintstick on paper
21 × 29.7 cm

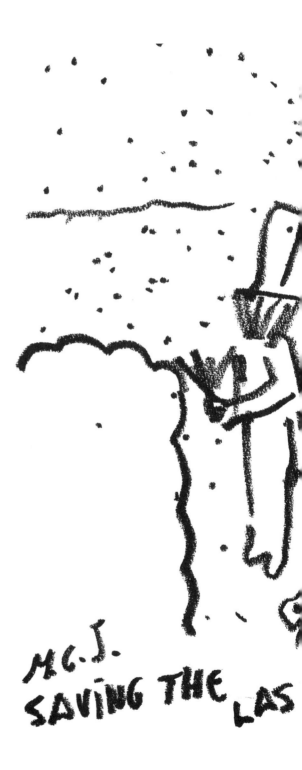

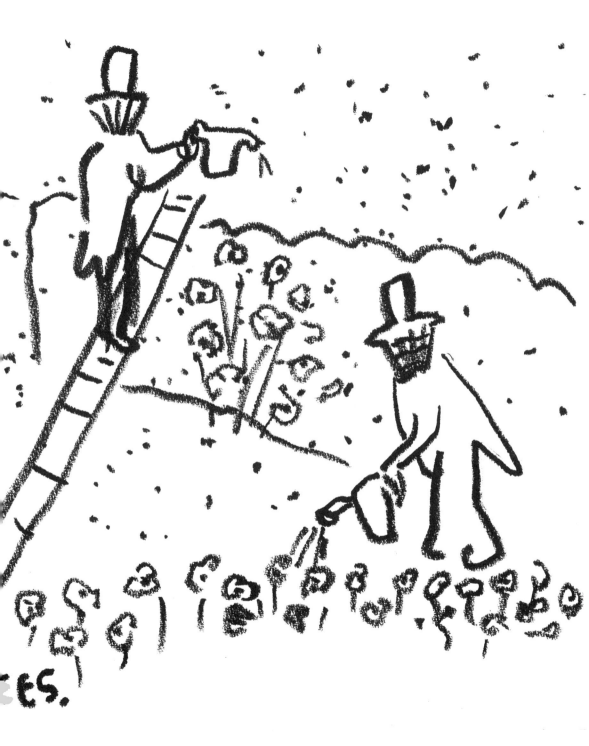

A Muslim, a Christian and a Jew
Trying to Make Themselves Visible
2016
Oil paintstick on paper
42 × 29.7 cm

N.G.J.
TRYING TO
MAKE THEMSELVES
VISIBLE

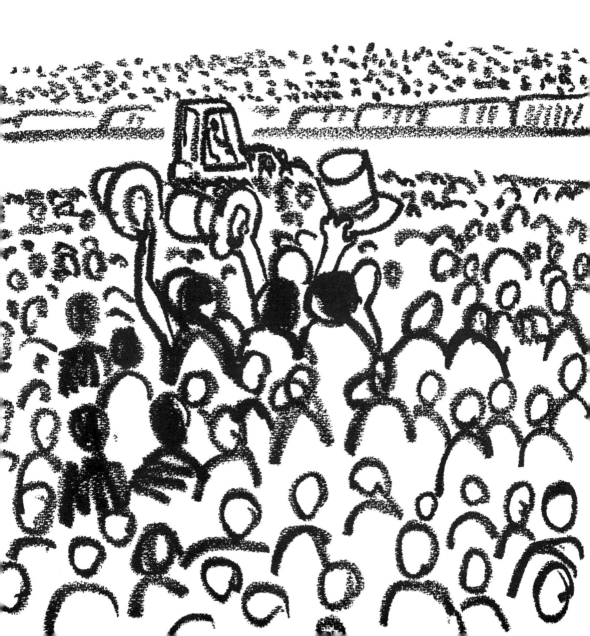

A Muslim, a Christian and a Jew
Going Back to Basics
2016
Oil paintstick on paper
42 × 29.7 cm

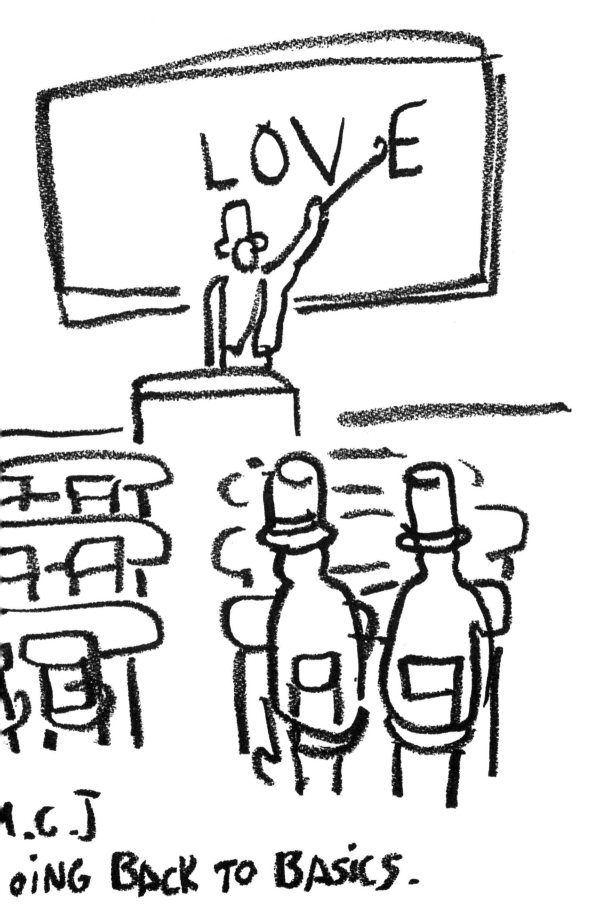

A Muslim, a Christian and a Jew
Listening to the Sounds of Mother Earth
2015
Oil paintstick on paper
21 × 29.7 cm

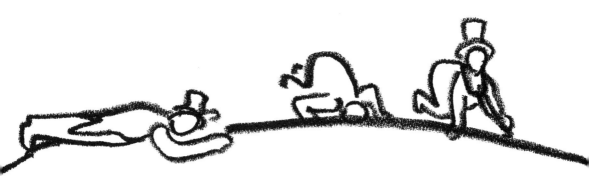

A Muslim, a Christian and a Jew
Trying to See Things From a Different Perspective
2016
Oil paintstick on canvas
90 × 80 cm

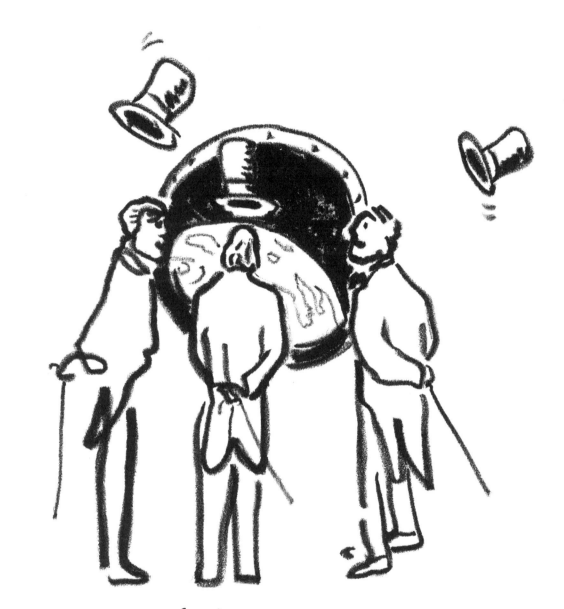

MUSLIM, A CHRISTIAN
ND A JEW TRYING TO SEE THINGS FROM A
DIFFERENT PERSPECTIVE

A Muslim, a Christian and a Jew
Feeling More Connected Than Ever,
But Much More Alone
2015
Ink on paper
29.7 × 21 cm

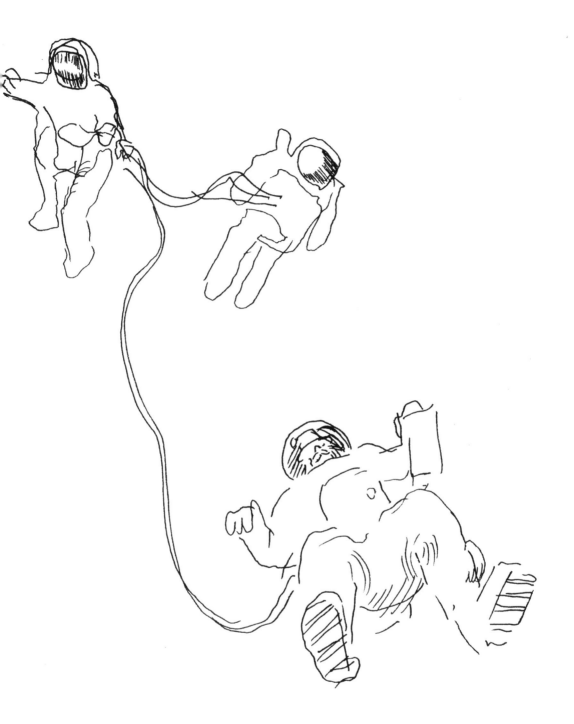

A MUSLIM, A CHRISTIAN AND A JEW
FEELING MORE CONNECTED THAN EVER-
BUT MUCH MORE ALONE

A Muslim, a Christian and a Jew
On the Dark Side of the Moon
2015
Ink and pencil on paper
21 × 29.7 cm

A MUSLIM
A CHRISTIAN &
A JEW
ON THE DARK
SIDE
OF
THE MOON

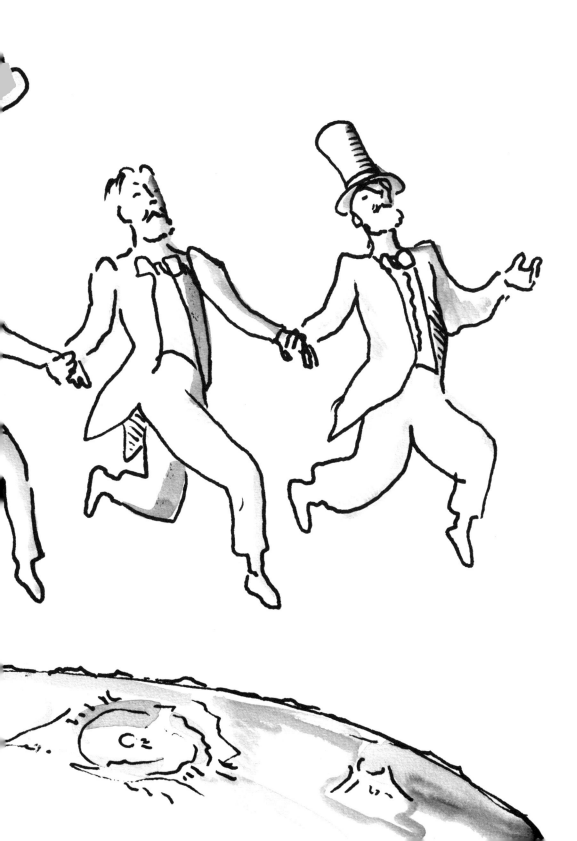

A Muslim, a Christian and a Jew
Feeling Chosen
2015
Ink on paper
42 × 29.7 cm

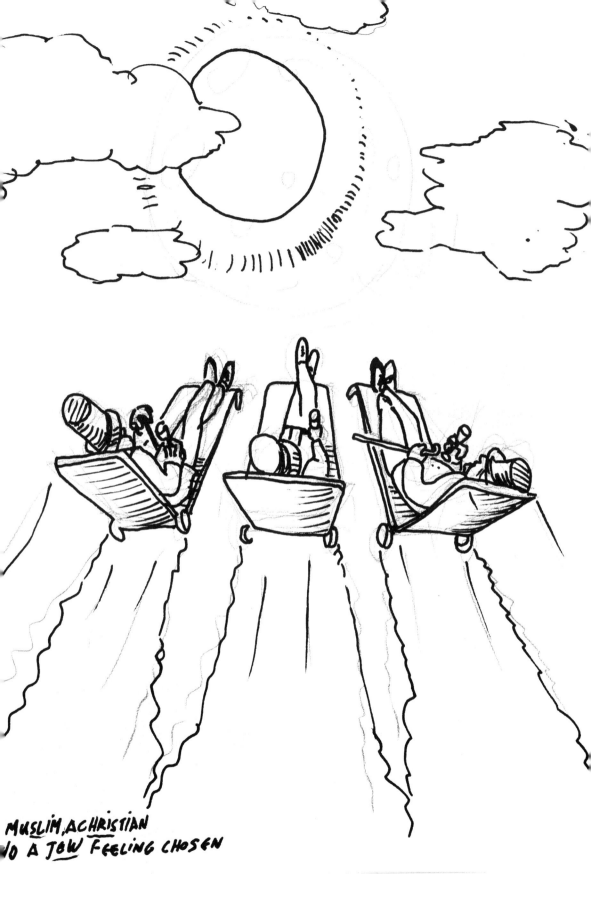

MUSLIM, A CHRISTIAN
NO A JEW FEELING CHOSEN

A Muslim, a Christian and a Jew
Feeling They Were Being Watched
2016
Oil paintstick and acrylic on canvas
90 × 80 cm

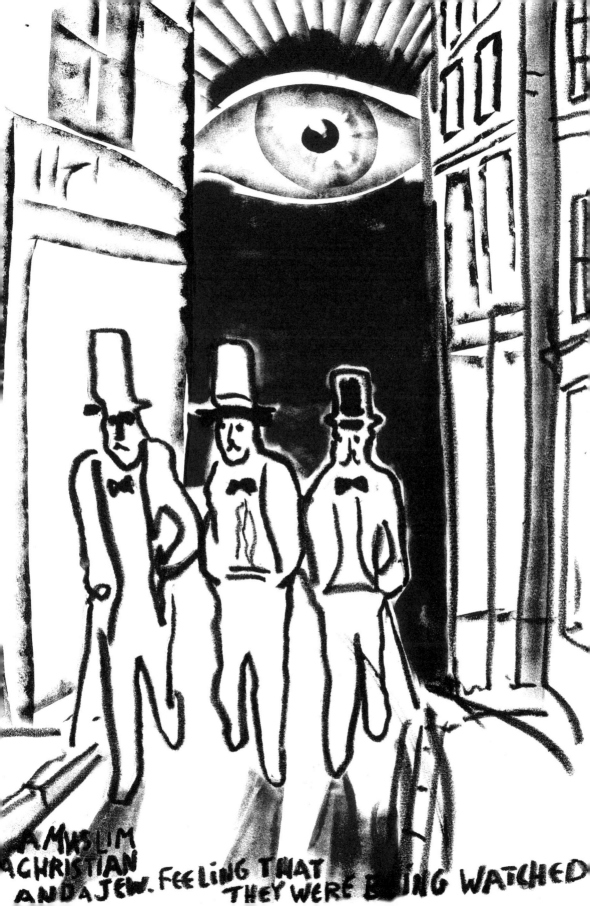

Eran Shakine

Eran Shakine is an artist who works in different mediums, such as painting, drawing, sculpture and site-specific public art.

He was born in 1962 in Israel to a French father and a Hungarian mother, both Holocaust survivors who came to Israel after the Second World War.

He lived in Paris, London and for seven years in New York City, where he received the "Art Matters" Scholarship and was the assistant of the COBRA movement artist, Karel Appel.

He exhibited one-man shows in The Drawing Center in New York and Mana contemporary New Jersey as well as in London, Paris, Brussels, Toronto and Tel Aviv.

His works are in the permanent collections of the British Museum in London; Ludwig Museum in Aachen, Germany; Tel Aviv Museum of Art, Israel and the Israel Museum, Jerusalem as well as many corporate and private collections.

He has just installed a permanent public sculpture "You and Me" in the center of Warsaw, Poland and a one-kilometre-long wall sculpture at the Ayalon Darom Highway in Israel.

A book of his paintings and drawings "Sunny Side Up" was published with Hirmer Verlag. Currently he is living in Tel Aviv.

Artist website: www.eranshakine.com

Selected Solo Exhibitions

2016	From Andy Warhol to Contemporary Art, Haifa Museum of Art
	A Muslim, a Christian and a Jew, The Jewish Museum, Berlin
	Looking at you / talking to myself, Zemack Contemporary Art Gallery, Tel Aviv
2015	Three painters, a rock star, a young girl and a psychoanalyst in one room
	MANA Contemporary, New Jersey
	The best of Eran Shakine, XXI gallery, Geneva
2014	Graffitigirl, Zemack Contemporary Art Gallery, Tel Aviv
2013	Art for Sale/Sail, Special project for Fashion Night, Tel Aviv
2012	Sunny Side Up, Zemack Contemporary Art Gallery, Tel Aviv
2011	Good help is hard to find…, Zemack Contemporary Art Gallery, Tel Aviv
2010	Catwalk, Gallery 39, Tel Aviv
	Minimal contradictions, TWIG Gallery, Brussels, Belgium
2009	Don't worry, Julie M. Gallery, Toronto
2008	Sabbath Match, Gallery 39, Tel Aviv
2007	The Artist Who did not Look Back, Gallery 39, Tel Aviv
2003	Domestic, Herzliya Museum of Contemporary Art
2000–02	Julie M. Gallery, Tel Aviv
1997	New Sculptures, Museum of Israeli Art, Ramat Gan
1995	Pools, Artists House, Jerusalem
1990	Herzliya Museum of Contemporary Art
1989	Selected 43, The Drawing Center, New York
1987	Givon Fine Arts Gallery, Tel Aviv

Selected Group Exhibitions

2016	Zona Maco Contemporary Art
	Art Miami, ART STAGE SINGAPORE, Art Central HK,
2015	Art 15, London, Art Miami, ART STAGE SINGAPORE, Art central HK
2014	START – SAATCHI GALLERY. London
2013	Pulse Art Fair Miami
2012	Puls Art Fair New York City, Shanghai Contemporary,
	Art Platform Los Angeles,
	Art Toronto, Art Miami, with Zemack Gallery
2012	"We have a champion!" Eretz Israel Museum, Tel Aviv
2011	Pulse Art Fair, Los Angeles and Miami, with Zemack Gallery
2010	Art Brussels, with TWIG Gallery
2009	Timebuoy, The Tel Aviv Biennial, Art, Tel Aviv
2008	Van Gogh in Tel Aviv, Rubin Museum, Tel Aviv
2005	On the Banks of the Yarkon, Tel Aviv Museum of Art
2000	The Vera, Silvia and Arturo Schwarz Collection, Tel Aviv Museum of Art
1999	Drawing: New Acquisitions, The Israel Museum, Jerusalem
1994	Contemporary Art Meeting, Tel Hai 94, Israel
	Israeli Sculpture 1948–1998, The Open Museum, Tefen
1984	Noemi Givon Gallery, Tel Aviv

Public Sculptures and Permanent Installations

"You and Me" 2015, at the Metropolitan Tower Plaza, Warsaw
Museum Tower Plaza, Tel Aviv
Pedestrian Mall, Rothschild St., Rishon LeZion
Rothschild Boulevard, Tel Aviv
Rothschild Tower by Richard Meier
Tel Aviv Artists House
Ashdod Park
Gan HaTzuk, Netanya
The College of Management, Rishon LeZion
Gan Kineret, Kfar Saba

Grants and Scholarships

1995 Artist in Residence, Cité Internationale des Arts, Paris
1989–90 Arts Matters, New York

Public Collections

The British Museum, London
Ludwig Museum, Aachen, Germany
The Israel Museum, Jerusalem
Tel Aviv Museum of Art
Herzliya Museum of Contemporary Art
The Open Air Museum, Tefen
Ein Harod Museum

Selected Bibliography

Barbara A. MacAdam, ARTnews,
Nuit Banai, Artforum International Magazine
Aviva Lori, Haaretz Magazine

Books

"Sunny Side Up", Hirmer 2011

A Muslim, a Christian and a Jew
Let Go of Prejudiced Attitudes
2016
Oil paintstick and acrylic on canvas
42 × 29.7 cm

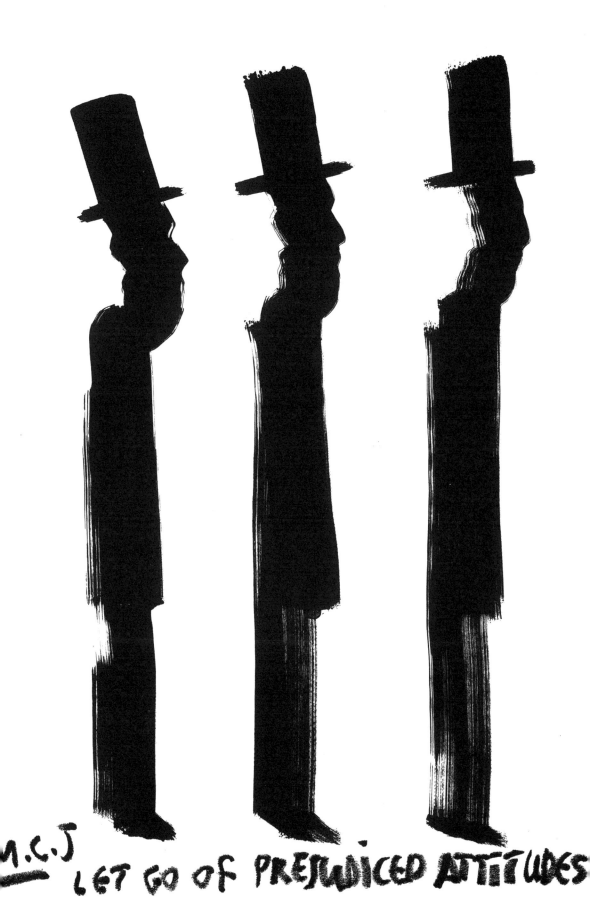

M.C.J

LET GO OF PREJUDICED ATTITUDES

Edition Jürgen B. Tesch

Eran Shakine
A Muslim, a Christian and a Jew
Knocking on Heaven's Door
Jürgen B. Tesch Hg.
Vorwort Edward van Voolen
2016. Text Englisch
Format ca. 16 × 22,5 cm
ca. 96 Seiten, ca. 40 Abb.
Klappenbroschur
ISBN 978-3-7774-2713-3

Eran Shakine
Sunny Side Up
Nuit Banai Hg.
2011. Text Englisch
Format 24 × 30 cm
120 Seiten, 60 Abb.
Flexocover
Vorzugsausgabe mit Grafik
ISBN 978-3-7774-5071-1

Maria Beykirch
Paper Dances
Jürgen B. Tesch Hg.
Einführung Gottfried Knapp
2016. Text Deutsch / Englisch
Format 24,5 × 30 cm
120 Seiten, 50 Abb.
Gebunden mit Schutzumschlag
ISBN 978-3-7774-2572-6

Max Mannheimer
The Marriage of Colours
Die Vermählung der Farben
Gottfried Knapp Hg.
2016. Text Deutsch / Englisch
Format 24,5 × 30 cm
144 Seiten, ca. 70 Abb.
Gebunden mit Schutzumschlag
ISBN 978-3-7774-2637-2

Maurice Weiss
Facing Time
Jürgen B. Tesch Hg.
Mit einem Beitrag von Alexander
Smoltczyk
2014. Text Deutsch / Englisch
Format 24,5 × 30 cm
128 Seiten, 57 Abb.
Gebunden mit Schutzumschlag
Vorzugsausgabe mit Fotografie
ISBN 978-3-7774-2242-8

Horst Thürheimer
Fire and Chalk
Feuer und Kreide
Gottfried Knapp Hg.
2014. Text Deutsch / Englisch
Format 24,5 × 32 cm
128 Seiten, 65 Abb.
Gebunden mit Schutzumschlag
ISBN 978-3-7774-2240-4

Monika Fioreschy
Interwoven Energy
Friedhelm Mennekes Hg.
2014. Text Deutsch / Englisch
Format 24,5 × 30 cm
136 Seiten, 55 Abb.
Gebunden mit Schutzumschlag
ISBN 978-3-7774-2243-5

Isabella Berr
Walking Dreams
Jürgen B. Tesch Hg.
Mit einem Beitrag von
Holden Luntz
2013. Text Deutsch / Englisch
Format 24,5 × 28 cm
128 Seiten, 60 Abb.
Gebunden mit Schutzumschlag
Vorzugsausgabe mit Grafik
ISBN 978-3-7774-2083-7

Franz Hitzler
Colour Is My Life
Farbe ist mein Leben
Wolfgang Jean Stock Hg.
2013. Text Deutsch / Englisch
Format 24,5 × 31,5 cm
128 Seiten, 66 Abb.
Gebunden mit Schutzumschlag
Vorzugsausgabe mit Grafik
ISBN 978-3791352794

Kadishman
Sculptures and Environments
Marc Scheps Hg.
2011. Text Englisch
Format 28 × 37 cm
128 Seiten, 140 Abb.
Gebunden mit Schutzumschlag
ISBN 978-3-7774-3501-5

Christina von Bitter
The Skin of Things
Die Haut der Dinge
Gottfried Knapp Hg.
2011. Text Deutsch / Englisch
Format 24,5 × 30 cm
160 Seiten, 102 Abb.
Gebunden mit Schutzumschlag
Vorzugsausgabe mit Grafik
ISBN 978-3-7774-3811-5

Bernd Zimmer
Bilder auf Leinwand
Werkverzeichnis 1976–2010
Anuschka Koos Hg.
2010. Text Deutsch
Format 29 × 29 cm
620 Seiten, 2249 Abb.
Gebunden im Schuber
ISBN 978-3-7774-3511-4

Jannis Kounellis
XXII Stations on an Odyssey
1976–2010
Marc Scheps
2010. Text Englisch
Format 30 × 30 cm
368 Seiten, 250 Abb.
Gebunden mit Schutzumschlag im
Schuber
ISBN 978-3-7913-5012-7

Leif Trenkler
I Love your long Eyes
Ich liebe deine langen Augen
Martin Tschechne Hg.
2009. Text Deutsch / Englisch
Format 24 × 30,5 cm
128 Seiten, 76 Abb.
Gebunden mit Schutzumschlag
Vorzugsausgabe mit Grafik
ISBN 978-3-7913-5037-0

Henning von Gierke
Flowing Gold
Goldener Strom
Vorwort Werner Herzog
2008. Text Deutsch / Englisch
Format 24 × 30 cm
240 Seiten, 420 Abb.
Gebunden mit Schutzumschlag
ISBN 978-3-7913-4132-3

Bernd Zimmer
Walter Grasskamp
Gespräche mit Bernd Zimmer
2008. Text Deutsch
Format 15,5 × 21 cm
160 Seiten, 40 farbige und
100 Schwarz-Weiß-Abb.
Klappenbroschur
ISBN 978-3-7913-4130-9

Yongbo Zhao
The Great Laughter
Das große Lachen
Gottfried Knapp Hg.
2008. Text Deutsch / Englisch
Format 24 × 30 cm
160 Seiten, 125 Abb.
Gebunden mit Schutzumschlag
Fünf Vorzugsausgaben mit einer
Radierung
Vorzugsausgabe mit Grafik
ISBN 978-3-7913-40333

Menashe Kadishman
Jacob Baal-Teshuva Hg.
2007. Text Englisch
Format 24 × 30 cm
160 Seiten, 160 Abb.
Gebunden mit Schutzumschlag
ISBN 978-3-7913-3844-6

Edition Jürgen B. Tesch

Published by
Hirmer Verlag GmbH
Nymphenburger Strasse 84
80636 Munich, Germany

Picture credits
Eran Shakine portrait by Shay Kedem

Hirmer project management
Rainer Arnold

English copy-editing and proofreading
Jane Michael

Layout and typesetting
WIGEL, Munich

Pre-press and repro
Reproline Genceller, Munich

Printing and binding
Friedrich Pustet GmbH, Regensburg

Printed in Germany

Bibliografische Information der Deutschen Nationalbibliothek
Die Deutsche Nationalbibliothek verzeichnet diese Publikation in der Deutschen
Nationalbibliografie; detaillierte bibliografische Daten sind im Internet über
http://www.dnb.de abrufbar.
Bibliographic information published by the Deutsche Nationalbibliothek
The Deutsche Nationalbibliothek lists this publication in the Deutsche
Nationalbibliografie; detailed bibliographic data is available on the Internet
at http://www.dnb.de.

www.hirmerverlag.de
www.hirmerpublishers.com

ISBN 978-3-7774-2713-3